Rhapsody In *BLUE* On Canvas

Famous Kansas City Jazz Night Clubs & "Joynts" of the 1930's 40's 50's and 60's illustrated in Art and Music.

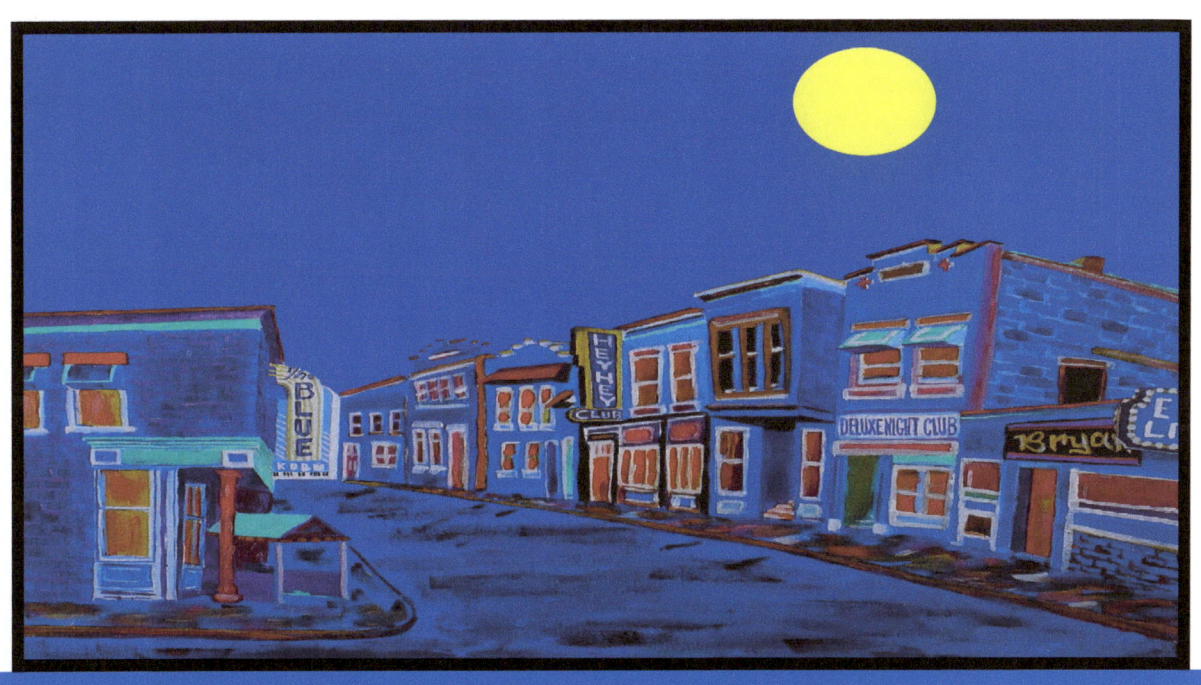

©MPGKC-BMI 2013 - Artwork : Sheron Y. Smith©

About The Artist

Sheron Smith's art work has been juried and displayed in art festivals, galleries and other venues in Kansas City . Although she has earned a BS and MS in education the fine arts have always played a major role throughout her life as an art collector and artist.

During the 1930s through the 1960s, Kansas City boasted more than 150 clubs and entertainment venues. Kansas City was once known as "Paris of the Plains". Sheron Smith KC night club jazz collection in art & song rekindles the mood of Kansas City's historic jazz era. It is a ongoing research / art project for her incorporating acrylic paint, inks, and gouache .

Sheron Smith's historic night club prints are on permanent display in the popular Waldo's Tap Room at 7433 Broadway in Kansas City, Missouri.

THE AUTHOR

Table Of Contents

Mardi Gras.. ………………………………………………………….4

Deluxe Night Club……………………………………………….8

Hey Hey Club……………………………………………………11

House of Swing……..……………………………………………...13

Papa's Place .………………………………………………………16

The Wiggle Inn.…………………………………………………18

The Blue Room .………………………………………………..21

Harlem Club.……………………………………………………24

Dante's Inferno.…………………………………………………27

Chesterfield Club……………………………………………….. 29

Derby Tavern.………………………………………………….32

Fox's ..……………………………………………………………35

King Kong Club.……………………………………………….38

Milton's Tap Room ..……………………………………………40

Red & Dutch.……………………………………………………41

Pla-Mor Ballroom.... .……………………………………………44

Rhapsody In Blue On Canvas Music Download .…………….47

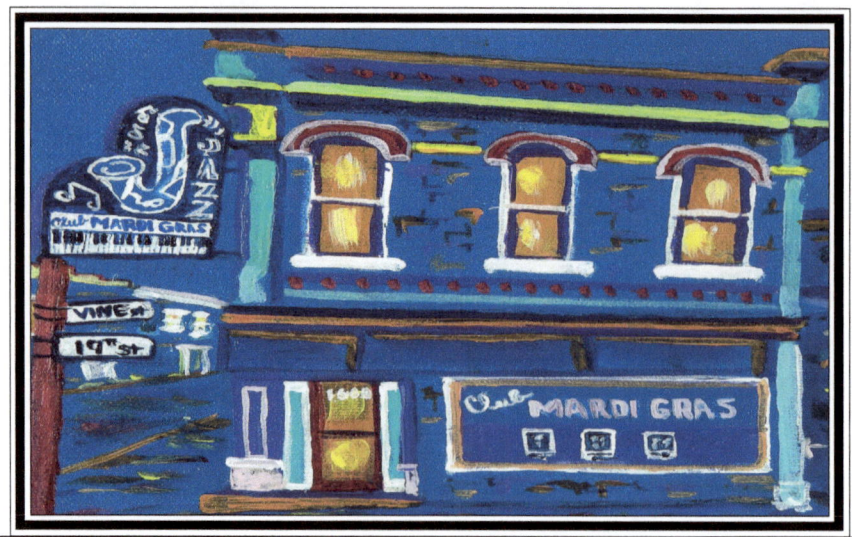

Mardi Gras - Kansas City

Medium Tempo Swing Style
Tempo = 180

Don W. Smith
Sheron Y. Smith - Art Composer

© MPGKC - BMI 2013 - Artwork : Sheron Y. Smith 2013©

Mardi Gras - Kansas City -

Mardi Gras - Kansas City -

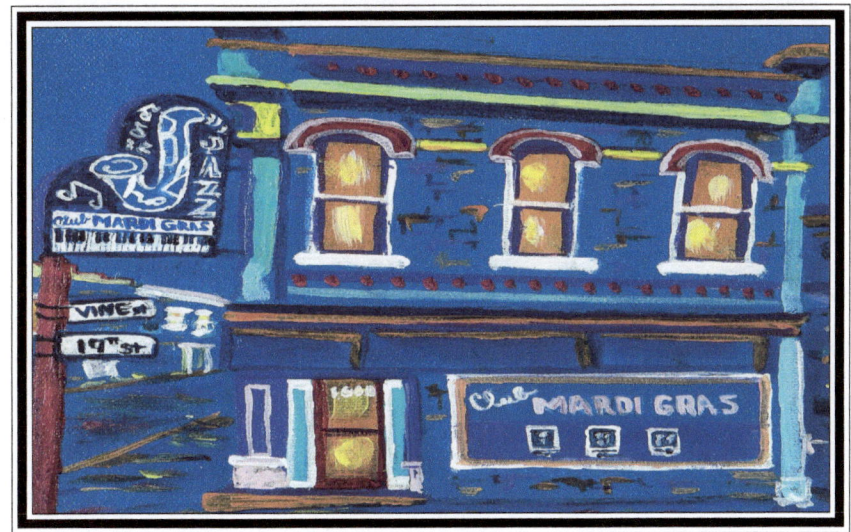

7

Mardi Gras - 1

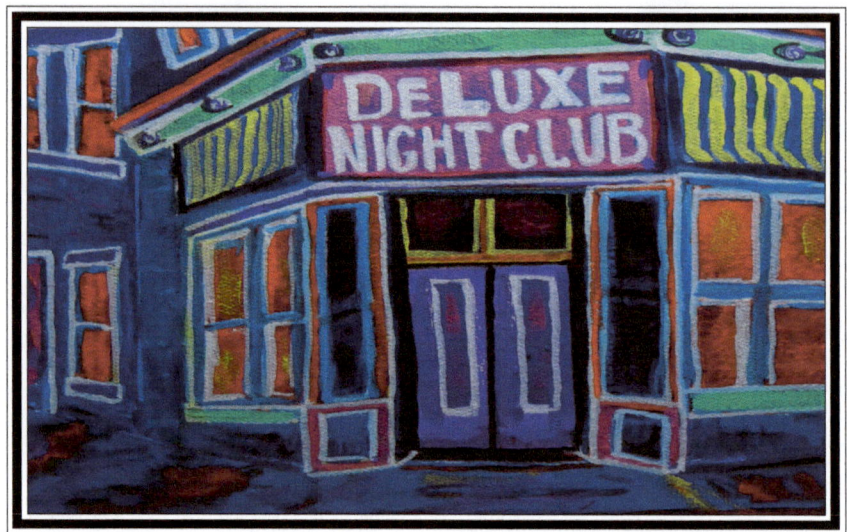

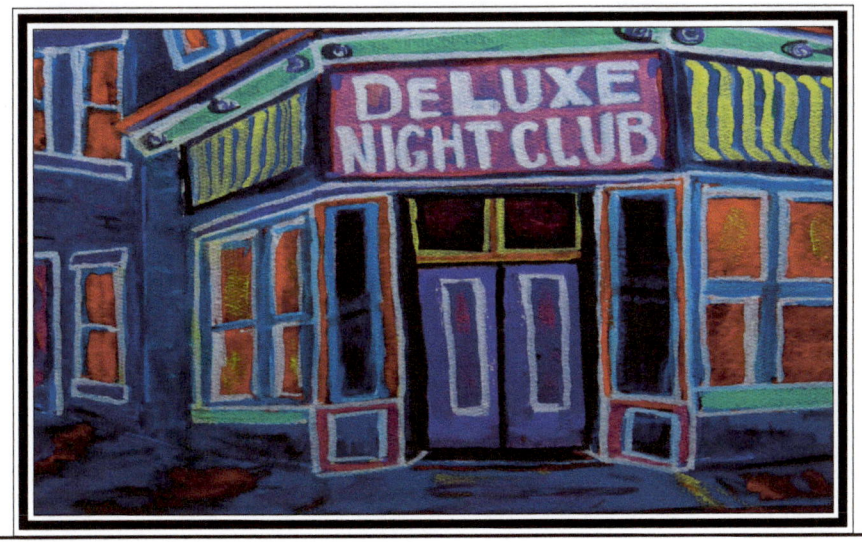

Deluxe Night Club - Kansas City -

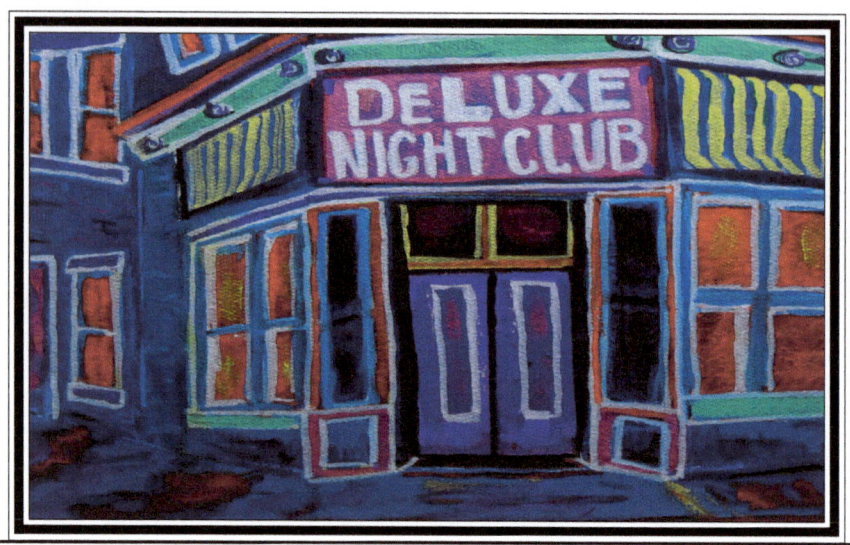

Deluxe Night Club - Kansas City -

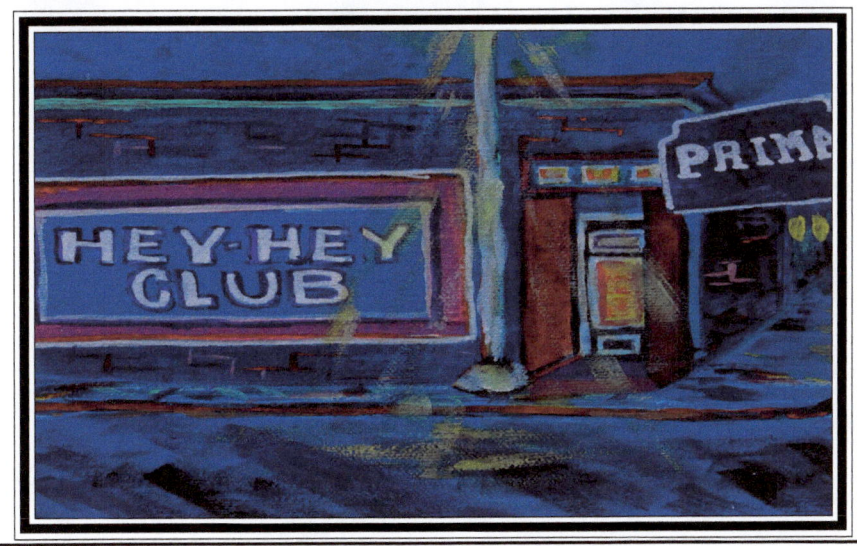

Hey Hey Club- Kansas City

Kansas City Blues
Tempo = 110

Don W. Smith
Sheron Y. Smith- Art Composer

c MPGKC-BMI-2013 - Artwort : Sheron Y. Smith -2013 c

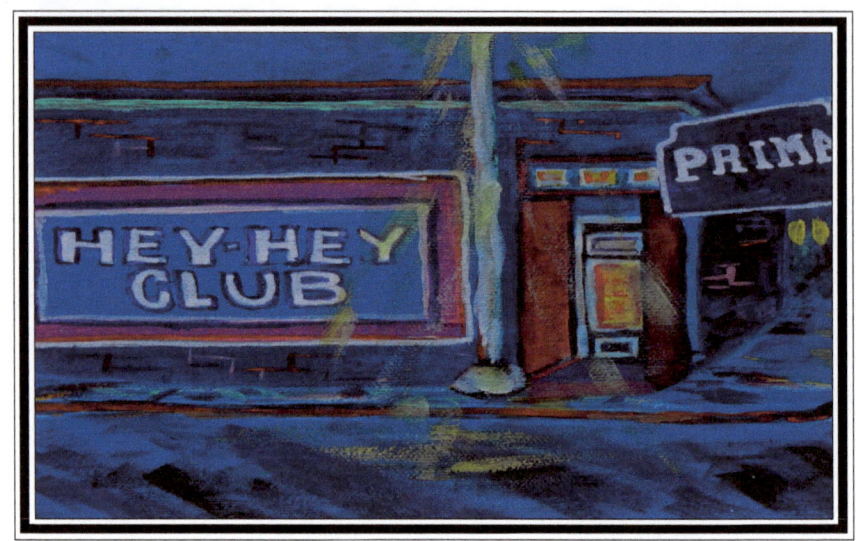
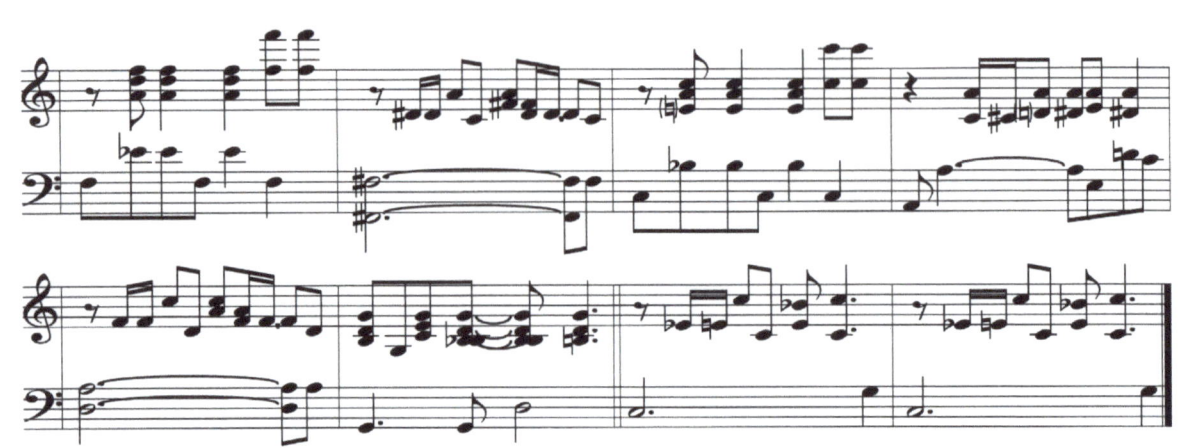

Hey Hey Club - Kansas City -

12

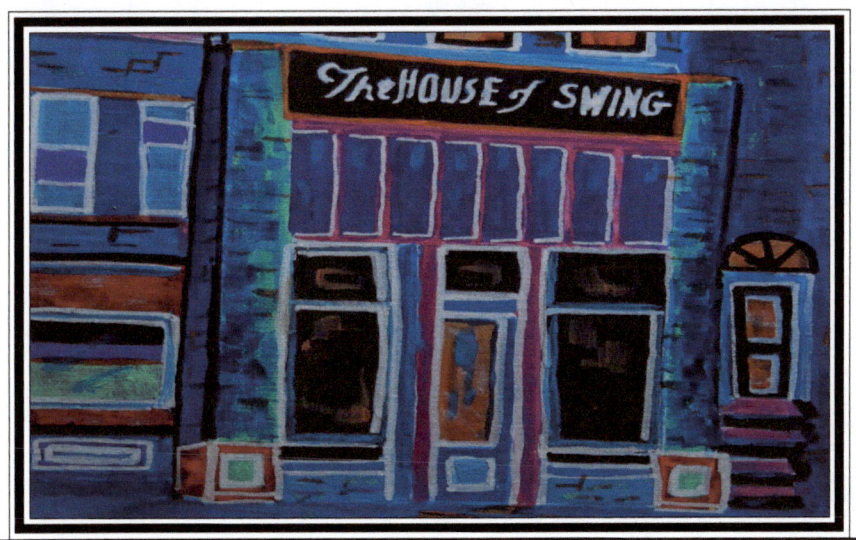

House Of Swing - Kansas City -

House Of Swing - Kansas City -

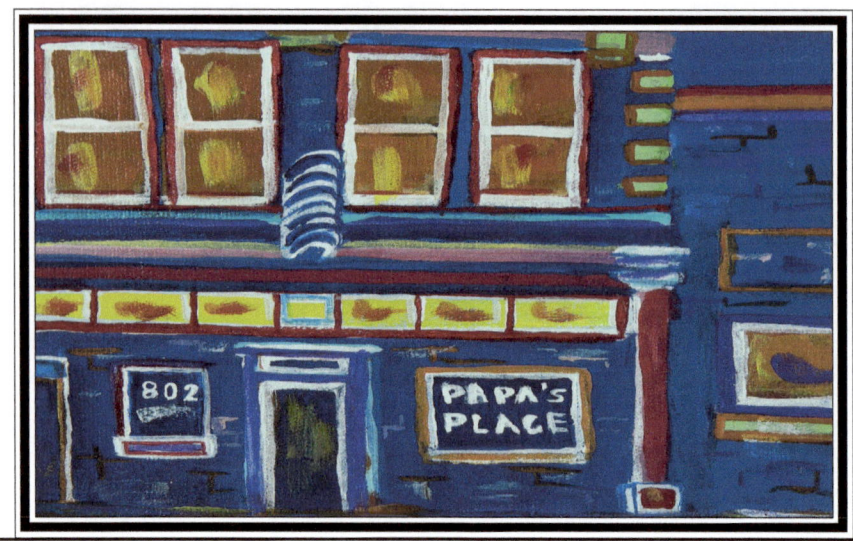

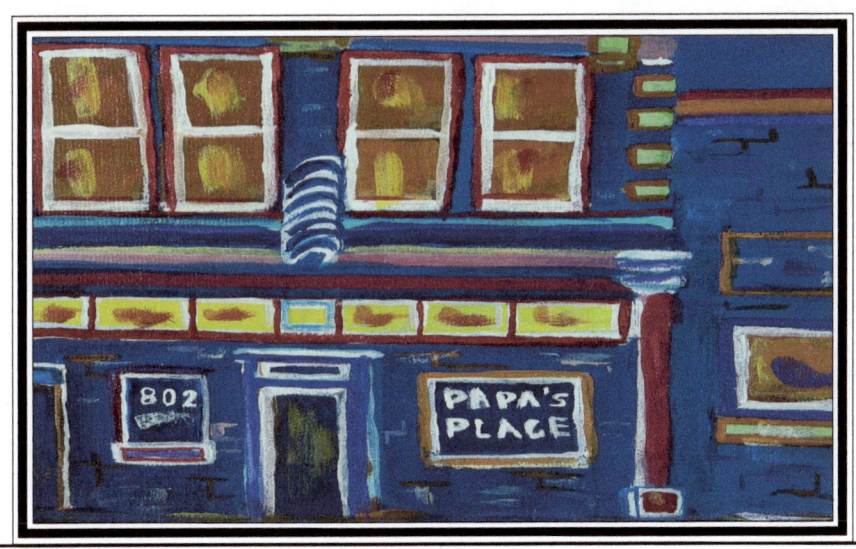

Papa's Place - Kansas City -

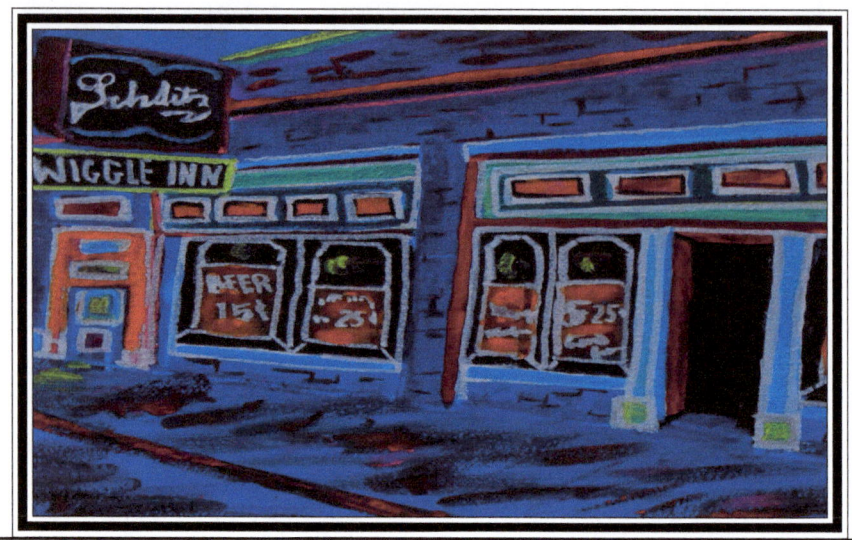

The Wiggle Inn- Kansas City

Kansas City Jita Bug
Tempo = 212

Don W. Smith
Sheron Y. Smith - Art Composer

©MPGKC - BMI - 2013 - Artwork : Sheron Y. Smith 2013©

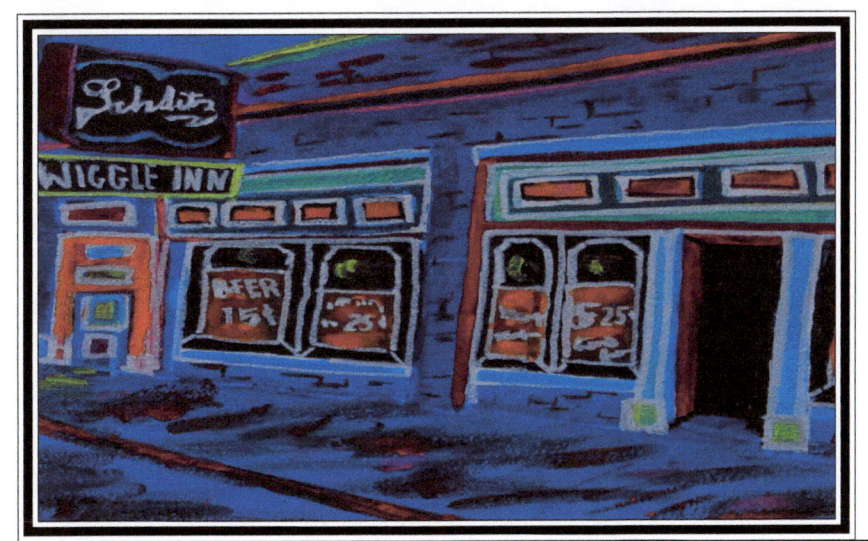

The Wiggle Inn- Kansas City

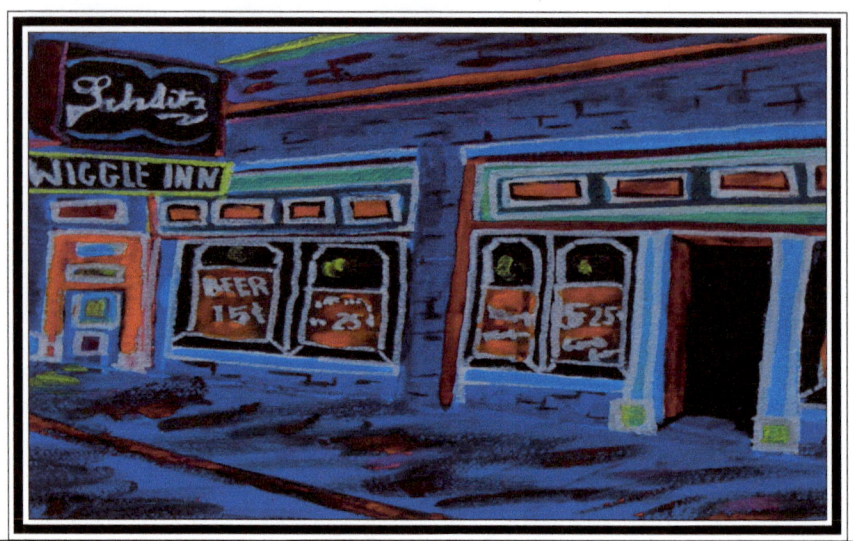
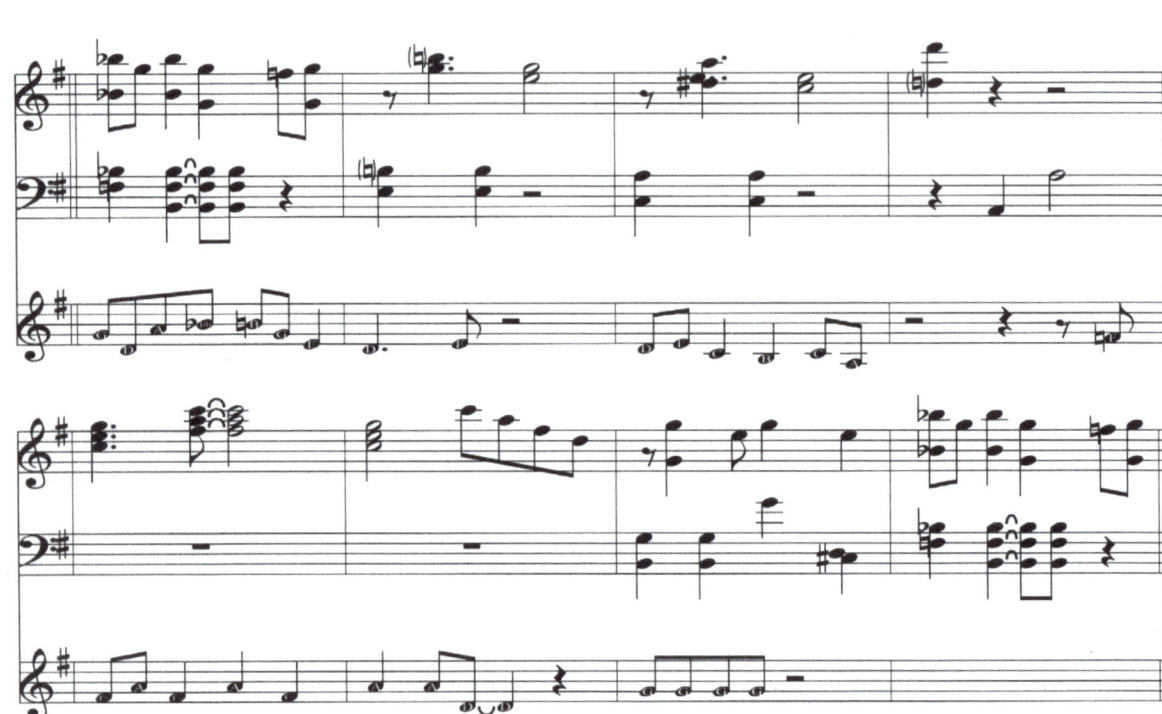

The Wiggle Inn- Kansas City -

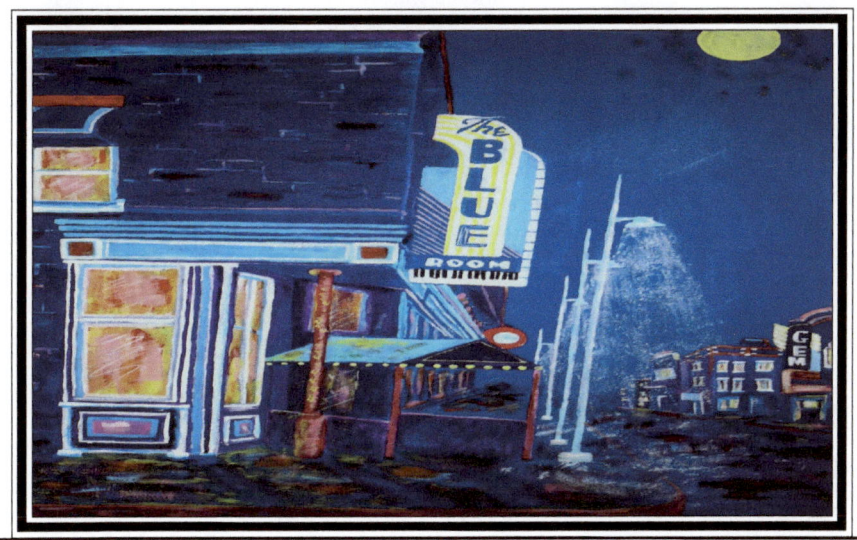

The Blue Room - Kansas City

Kansas City Jazz
Tempo = 150

Don W. Smith
Sheron Y. Smith - Art Composer

©MPGKC- BMI - 2013 - Artwork : Sheron Y. Smith 2013©

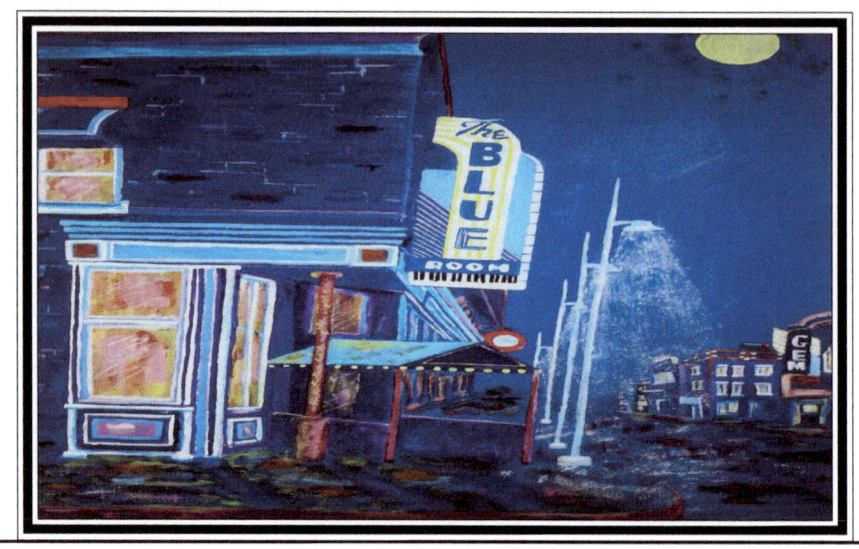

The Blue Room - Kansas City -

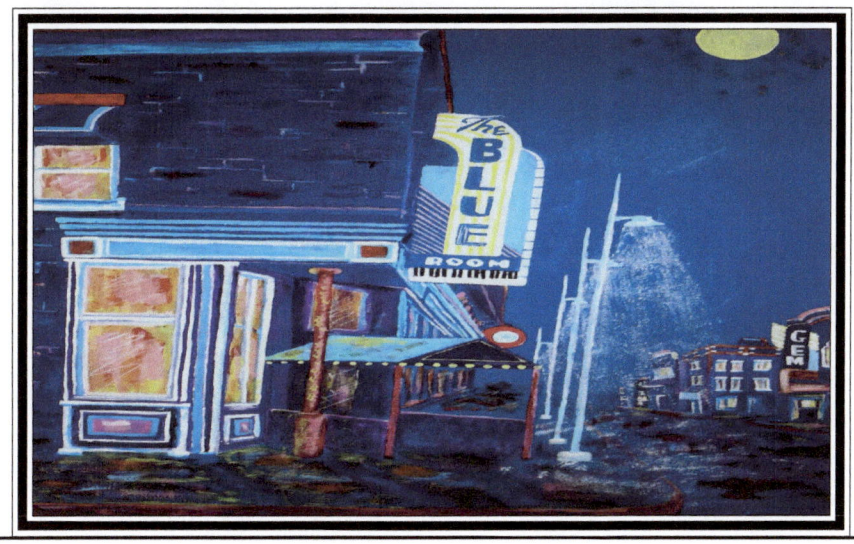

The Blue Room - Kansas City -

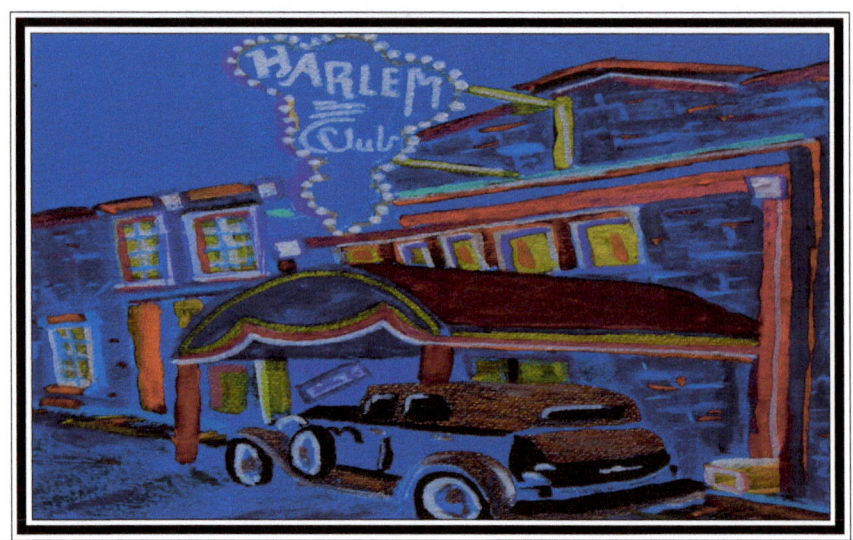

The Harlem Club - Kansas City -

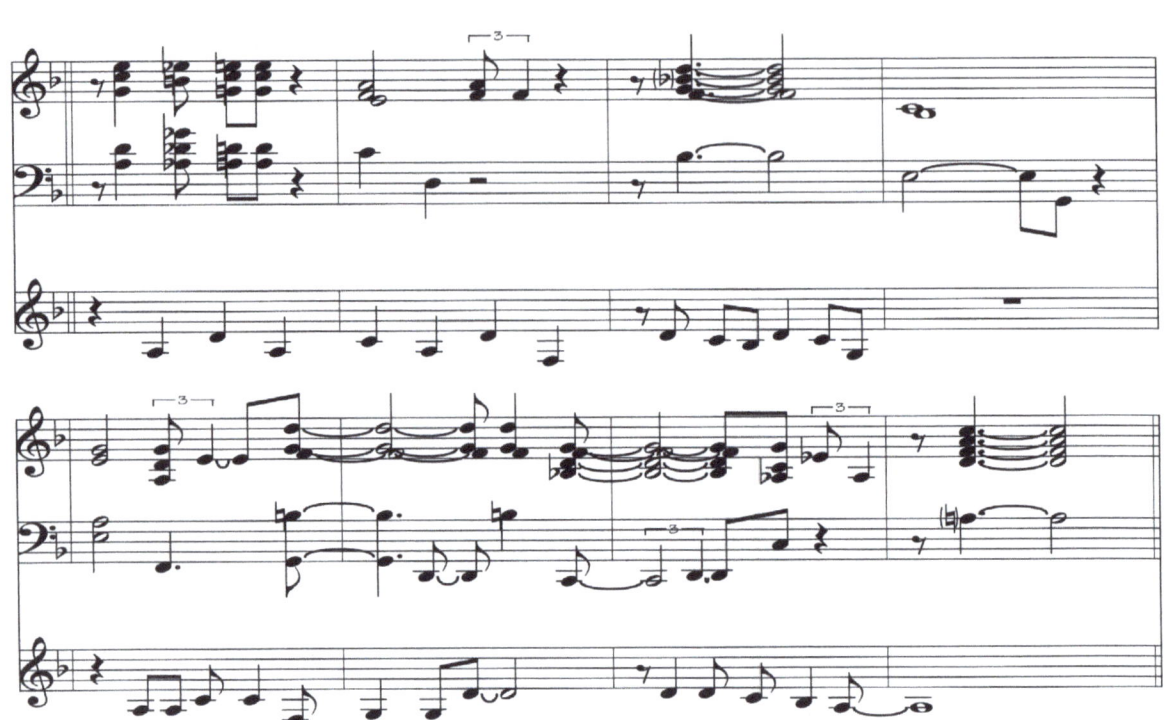

The Harlem Club - Kansas City -

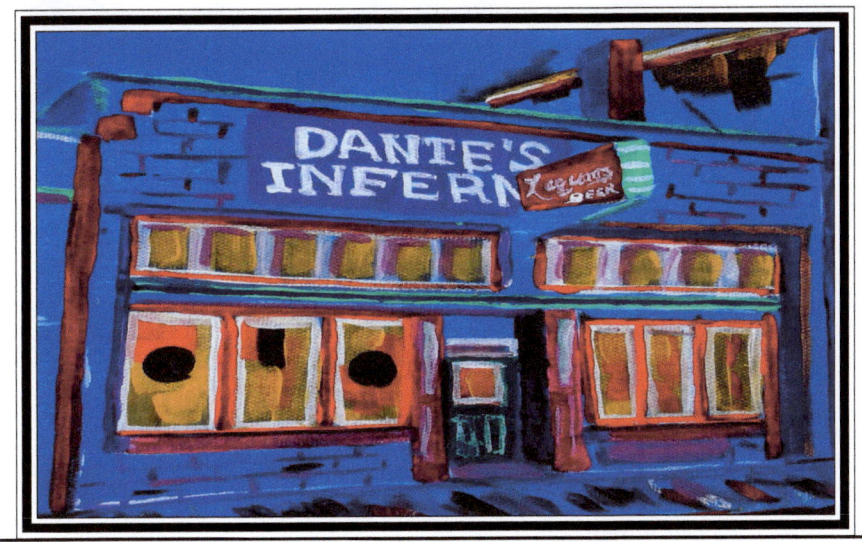

Dante's Inferno - Kansas City

Kansas City Jazz
Tempo = 121

Don W. Smith
Sheron Y. Smith - Art Composer

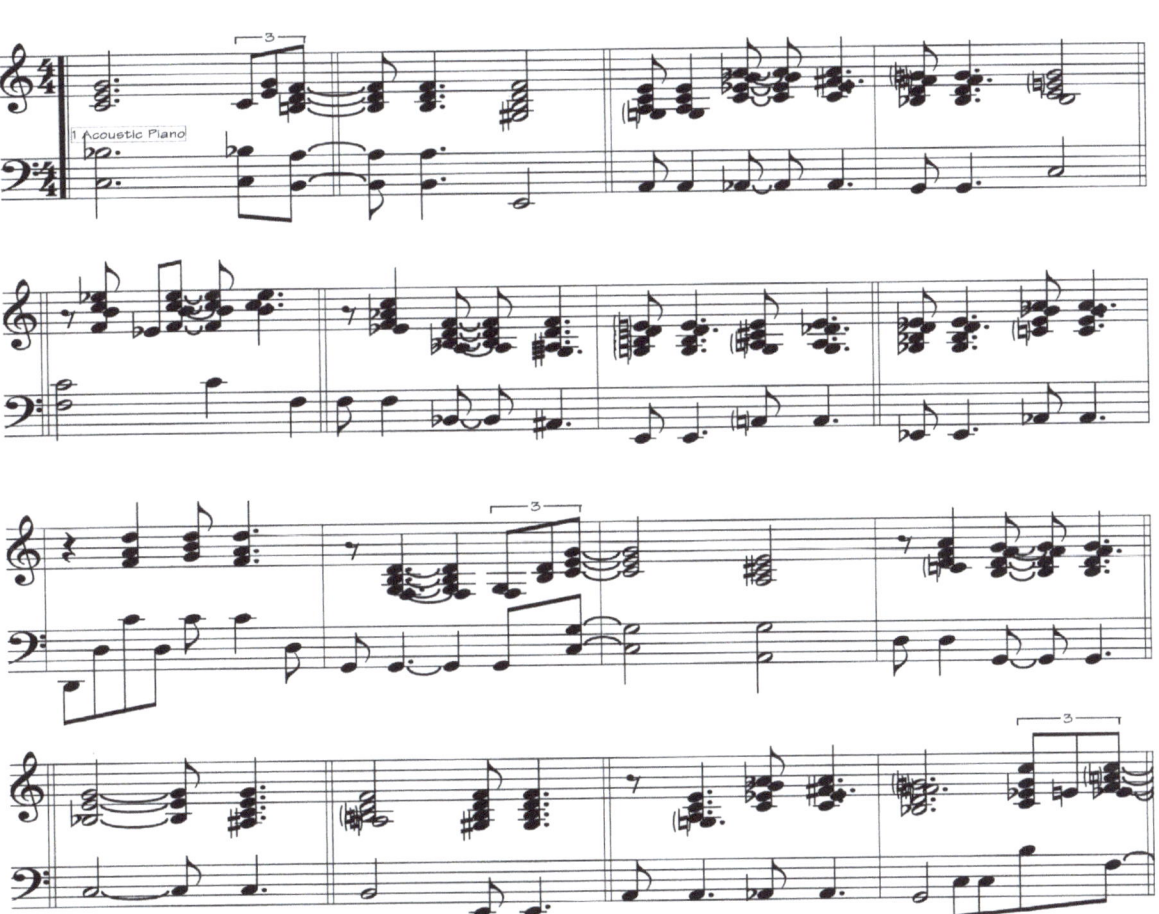

© MPGKC - BMI 2013 - Artwork : Sheron Y. Smith 2013©

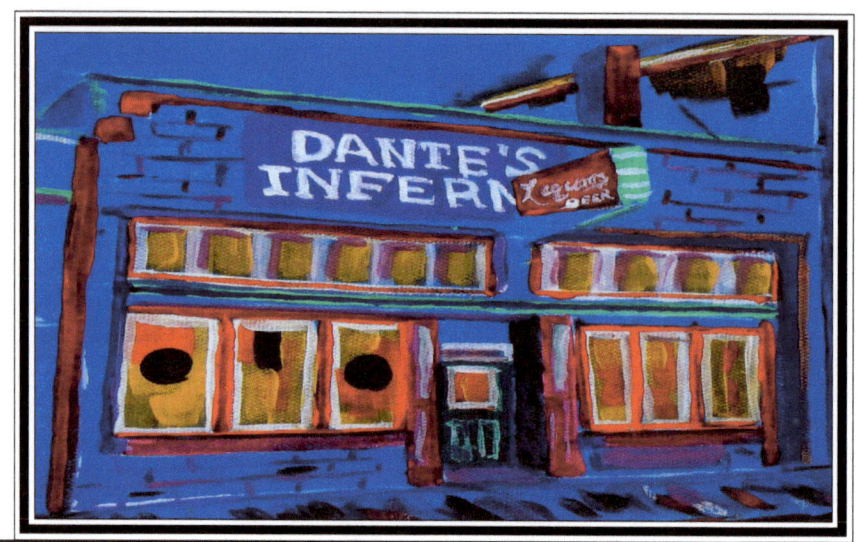
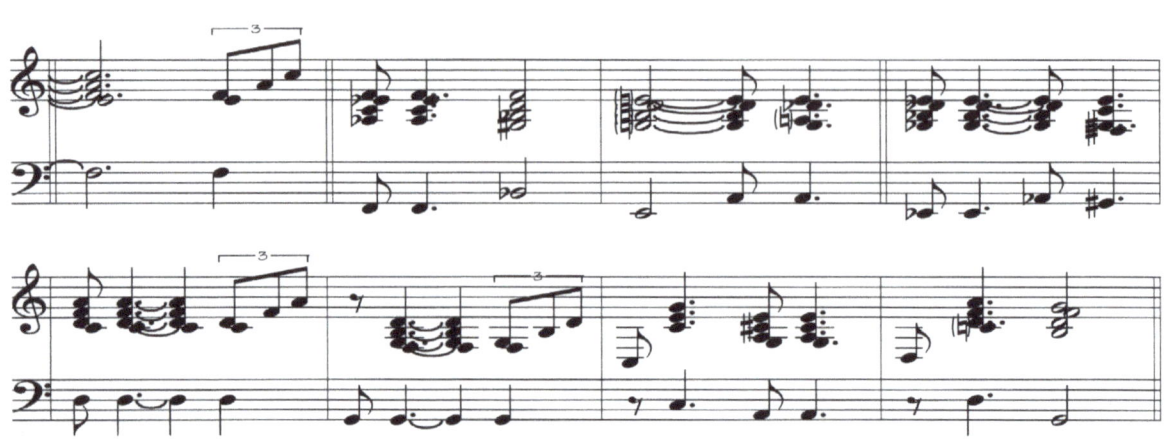

Dante's Inferno - Kansas City -

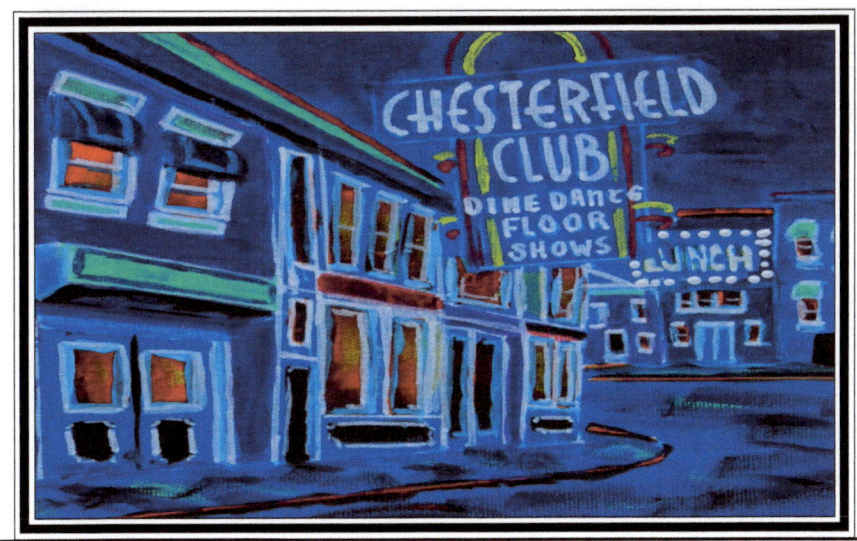

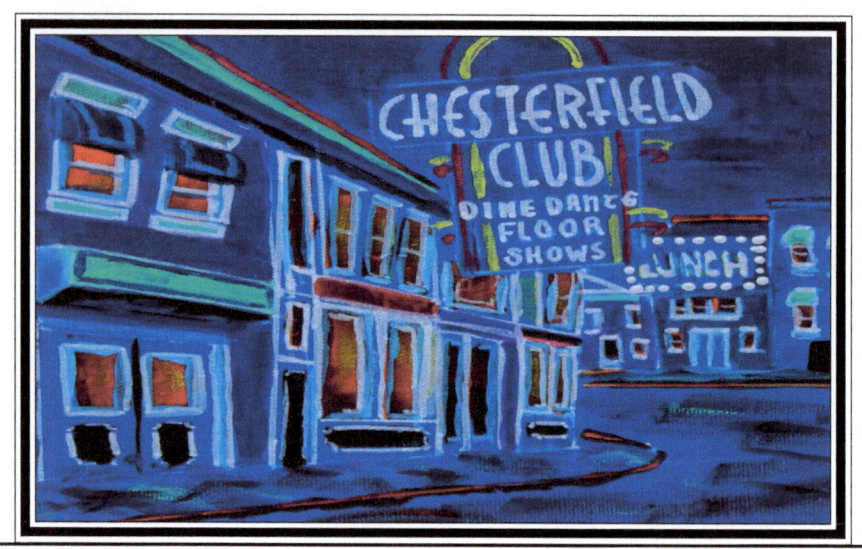

Chesterfield Club - Kansas City -

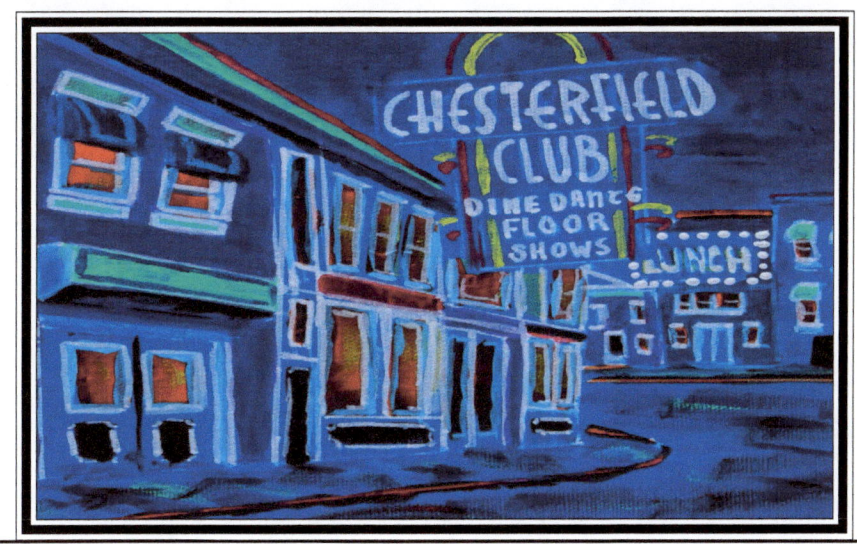

Chesterfield Club - Kansas City -

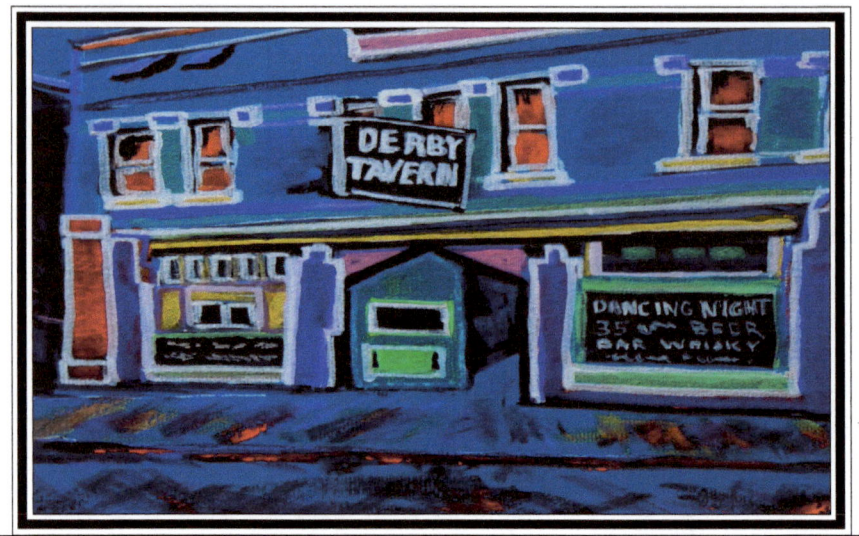

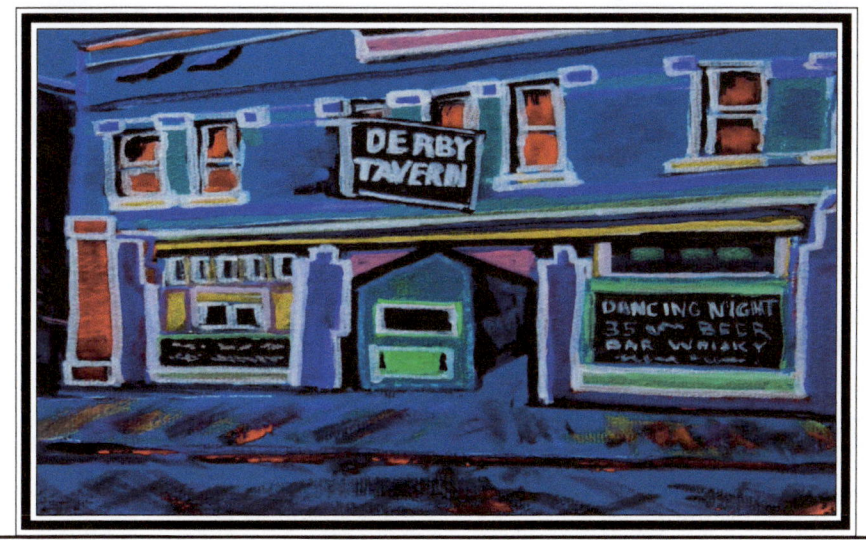

Derby Tavern - Kansas City -

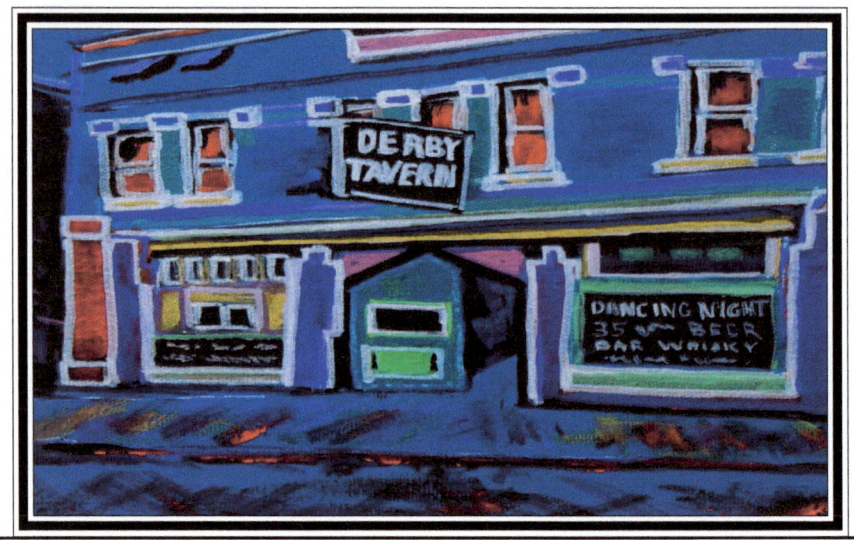

Derby Tavern - Kansas City

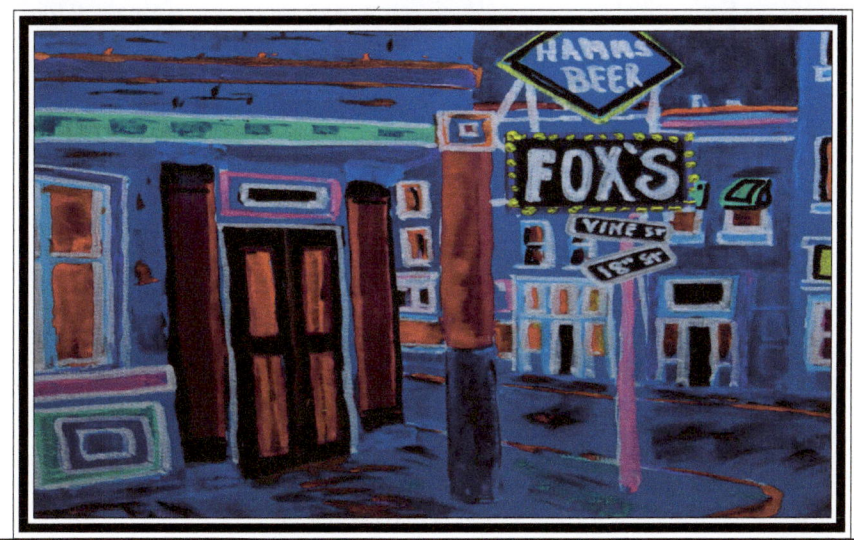

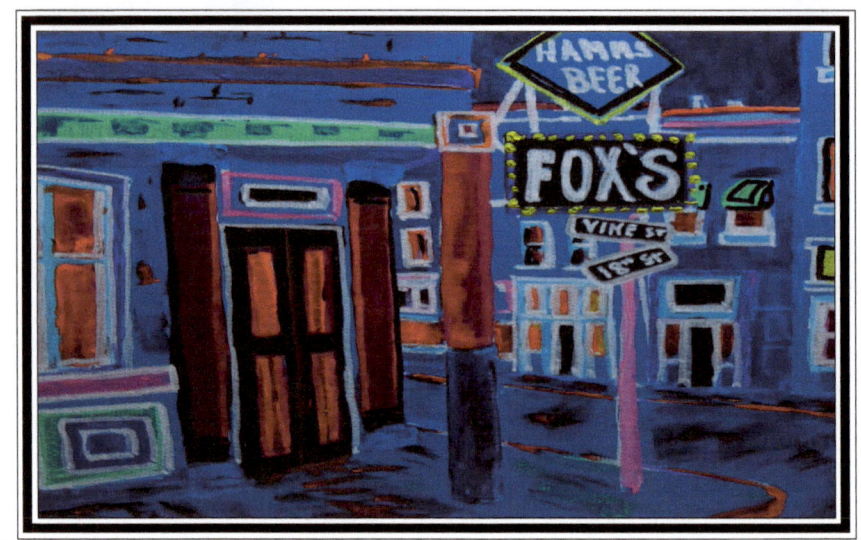

Foxes Club - Kansas City -

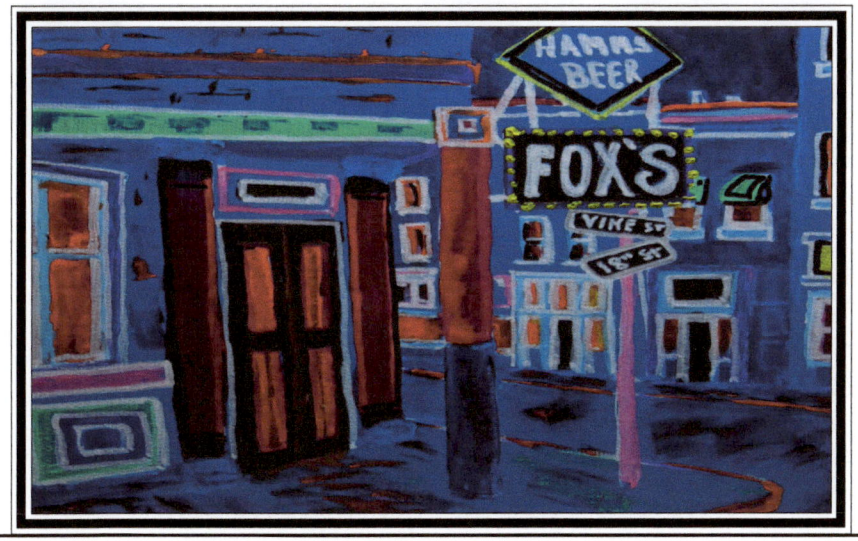

Foxes Club - Kansas City -

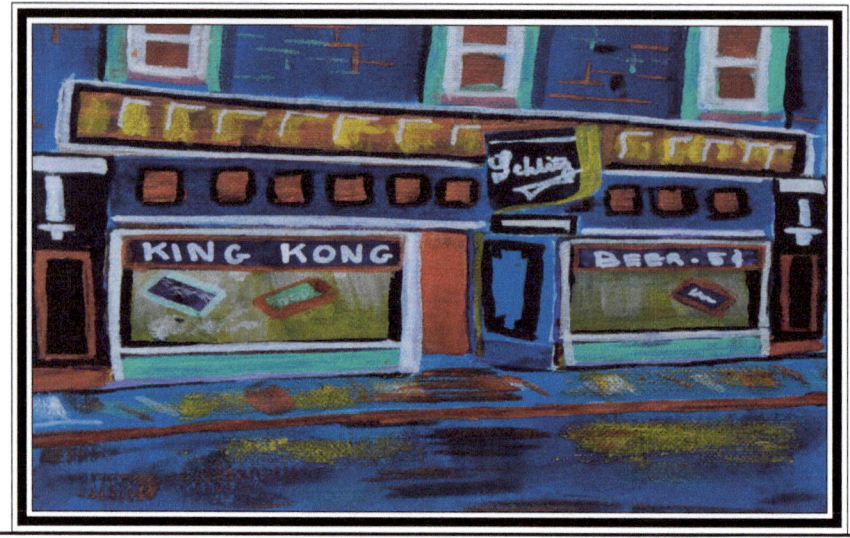

King Kong Club - Kansas City

Slow 12/8 Kansas City Blues
Tempo = 170

Don W. Smith
Sheron Y. Smith - Art Composer

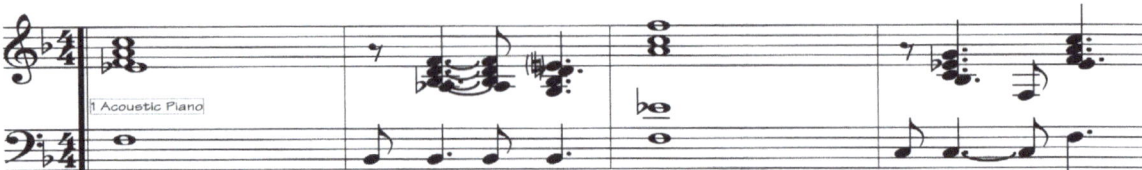
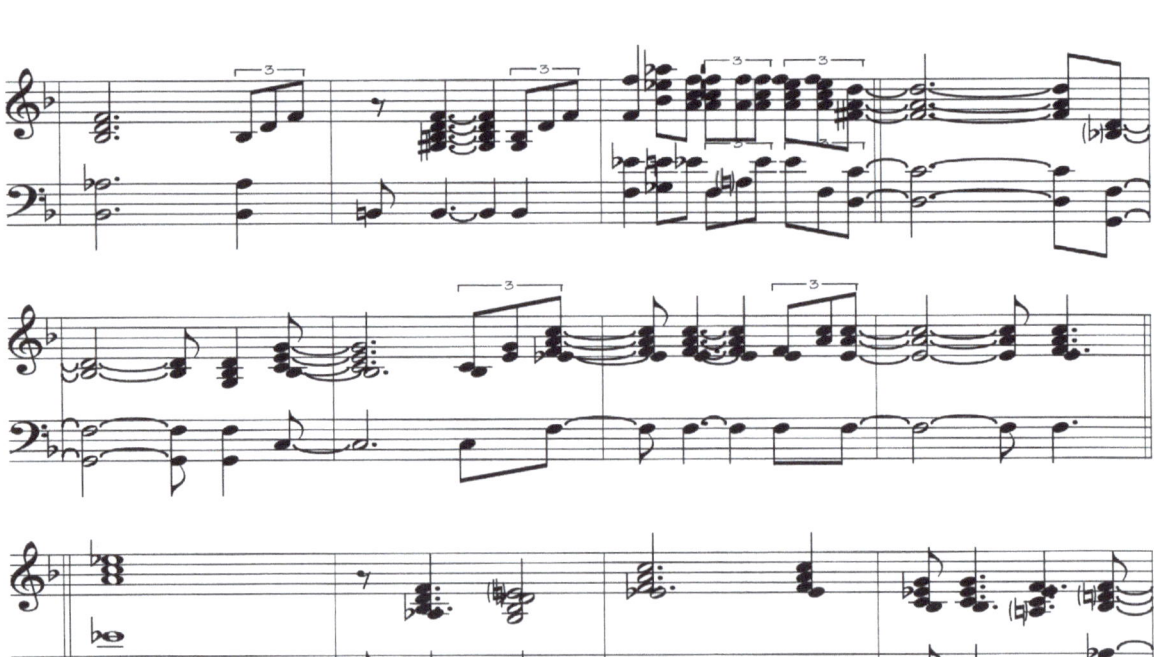

© MPGKC - BMI 2013 - Artwork : Sheron Y. Smith 2013©

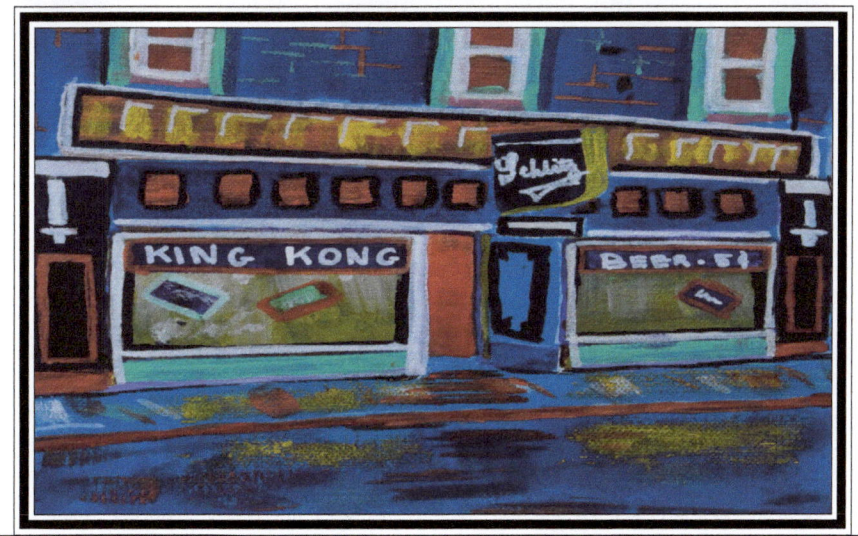
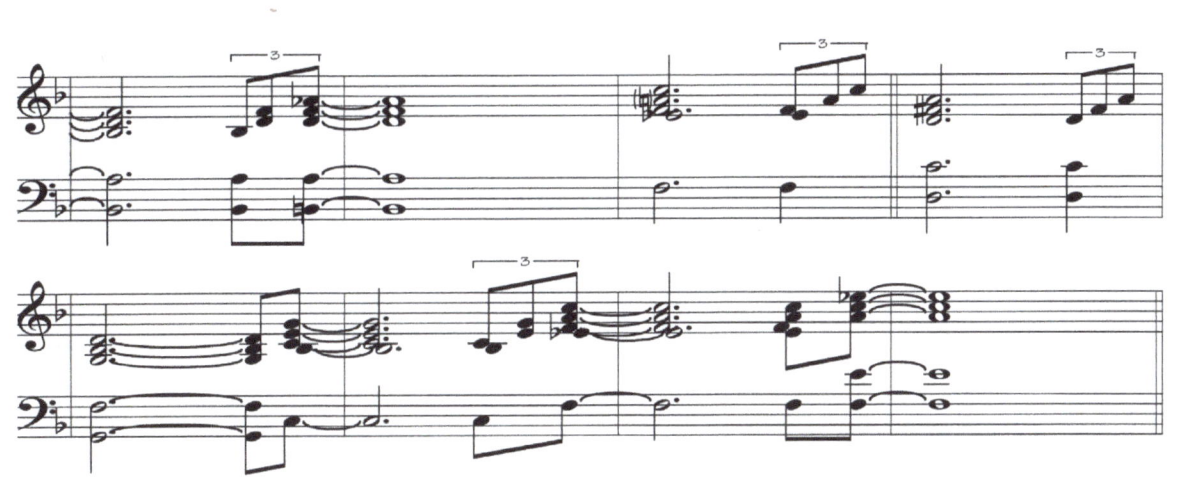

King Kong Club - Kansas City -

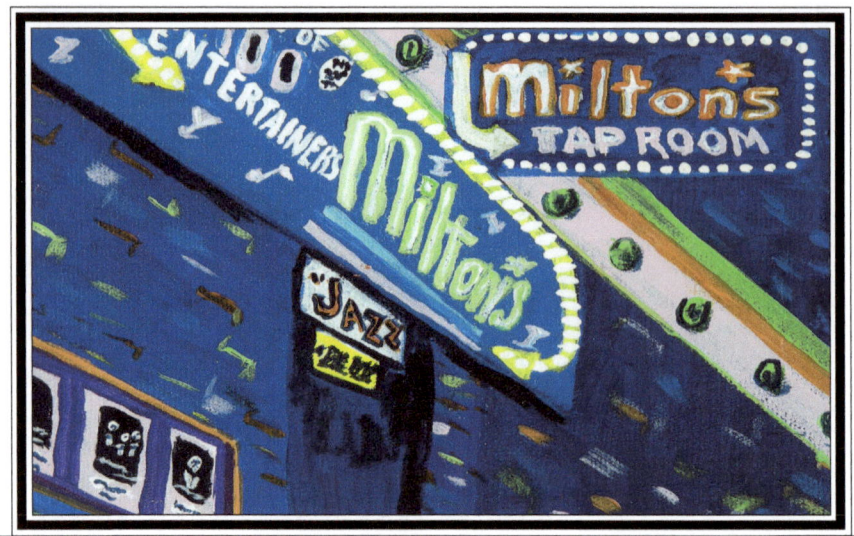

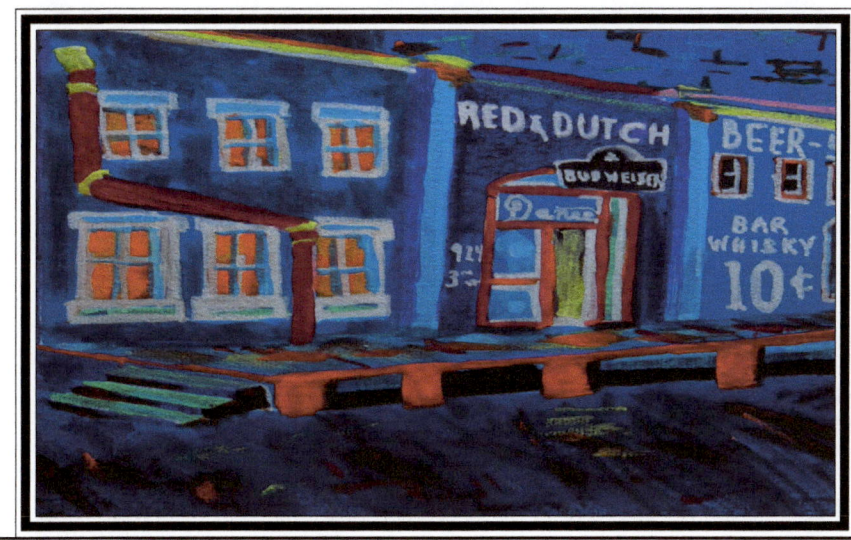

Red & Dutch Club - Kansas City

Dixieland 3
Tempo = 230

Don W. Smith
Sheron Y. Smith - Art Composer

©MPGKC - BMI 2013 - Artwork : Sheron Y. Smith 2013©

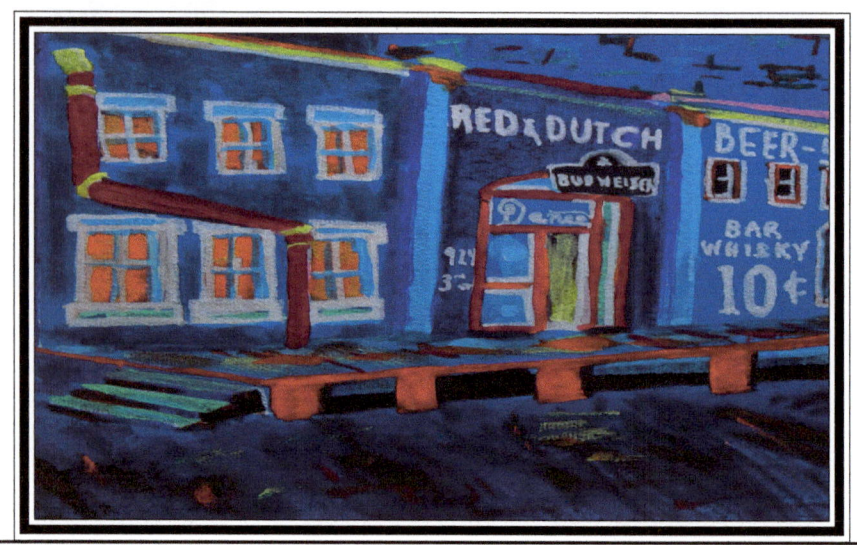

Red & Dutch Club - Kansas City -

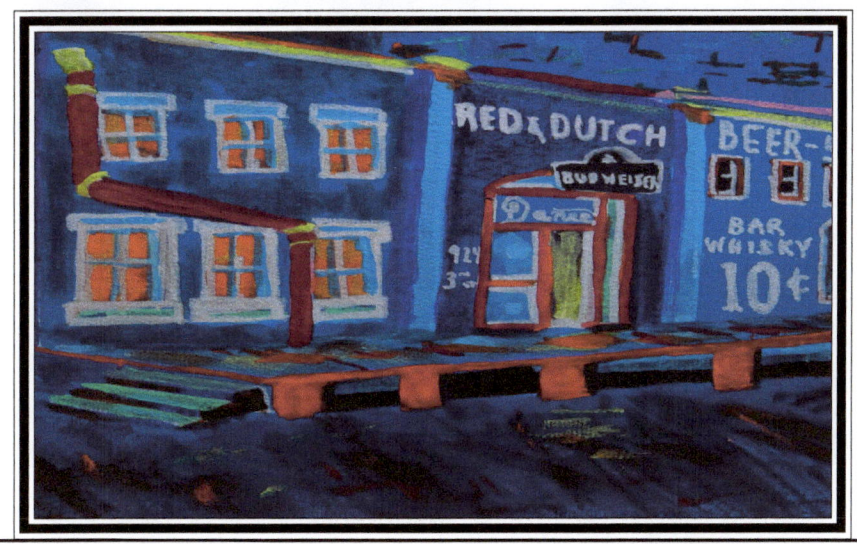

Red & Dutch Club - Kansas City -

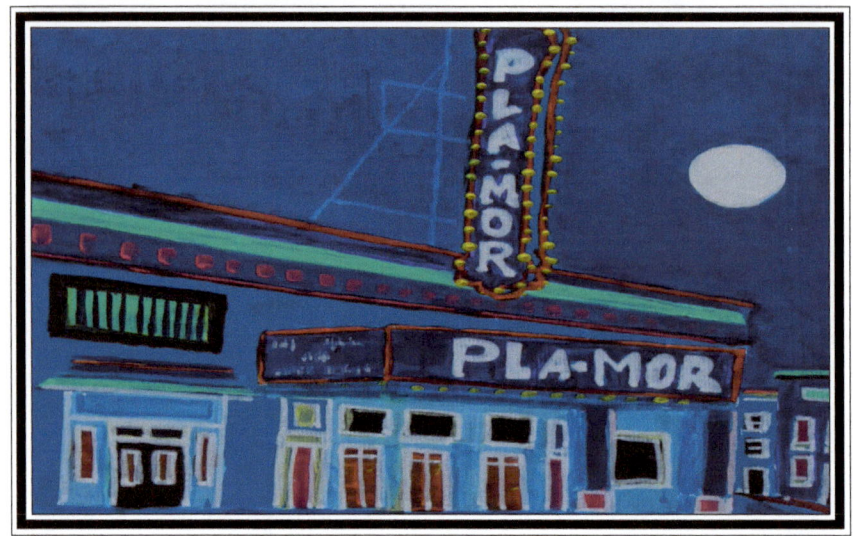

Pla-Mor Ballroom - Kansas City

Jazz Waltz
Tempo = 115

Don W. Smith
Sheron Y. Smith - Art Composer

© MPGKC - BMI 2013 - Artwork : Sheron Y. Smith 2013©

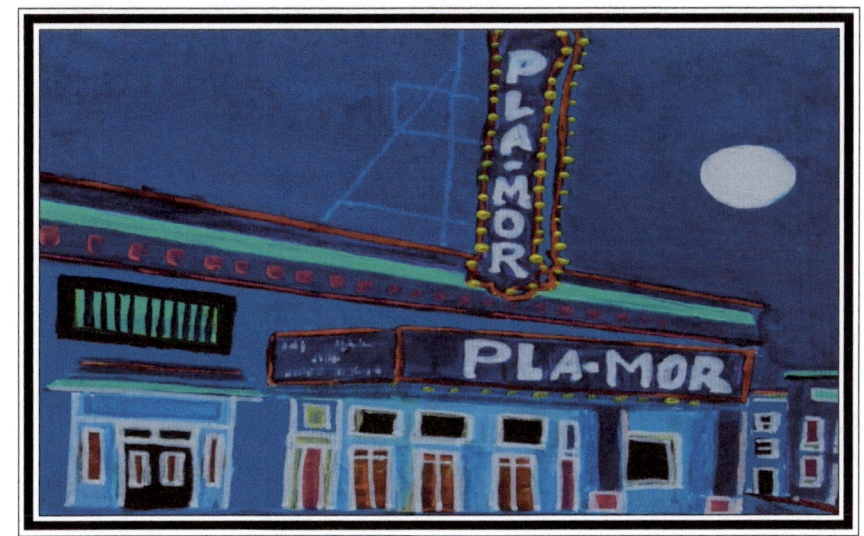

Pla-Mor Ballroom -Kansas City -

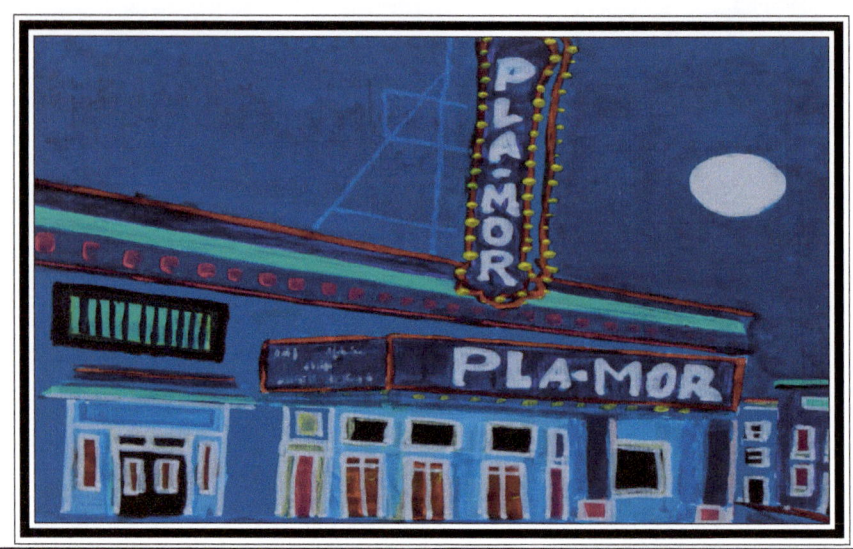

Pla-Mor Ballroom -Kansas City -

Rhapsody In *BLUE* On Canvas

Hear and download the full version of the music of the famous Kansas City night clubs and "joynts" in this book which includes the melody, piano, bass guitar and drums. Available on CD too at Amazon .Com.

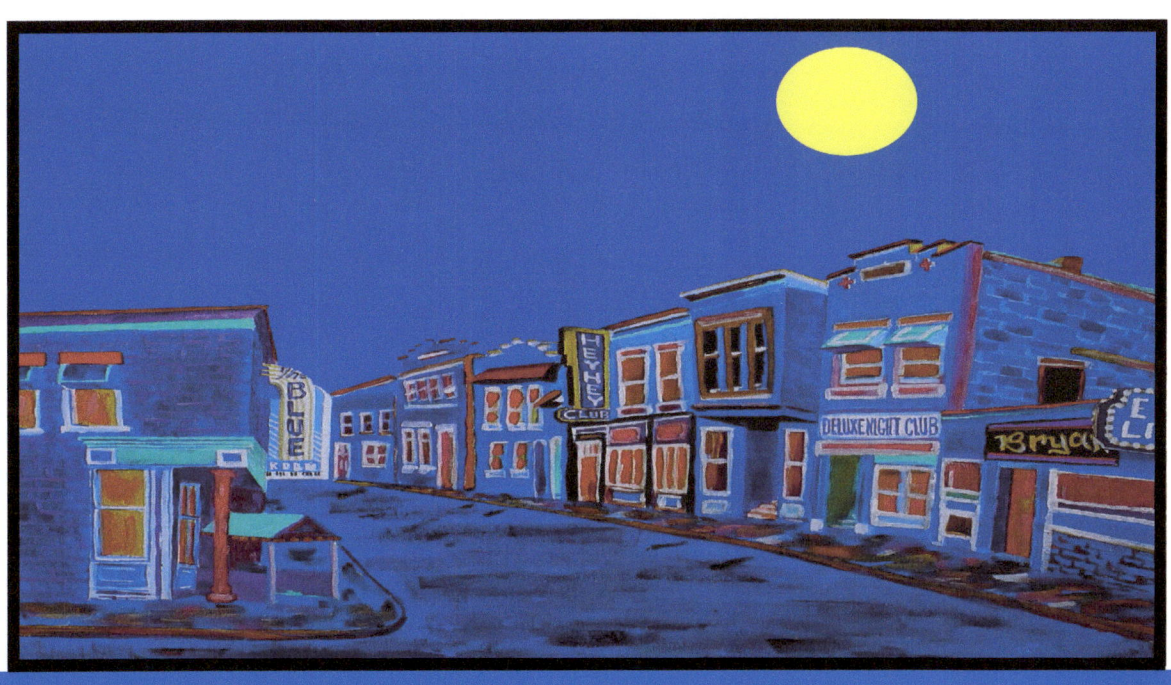

©MPGKC-BMI 2013 - Artwork : Sheron Y. Smith©

www.ingramcontent.com/pod-product-compliance
Lightning Source LLC
Chambersburg PA
CBHW040752200526

45159CB00025B/1863